CW01346149

> To Simon,
> a welcome supporter of a
> "hope-giver" (Thembisa) in
> South Africa.
> Chris Mann
> Oxford 2008

LIFELINES

Chris Mann – *poems*

Adrian Craig – *prose*

Julia Skeen – *artwork*

UNIVERSITY OF KWAZULU-NATAL PRESS

Published in 2006 by University of KwaZulu-Natal Press
Private Bag X01
Scottsville 3209
South Africa
E-mail: books@ukzn.ac.za
Website: www.ukznpress.co.za

© 2006 Poems Chris Mann, © 2006 Scientific notes Adrian Craig, © Artwork Julia Skeen

All rights reserved. No part of this publication may be reproduced or transmitted
in any form or by any means, electronic or mechanical, including photocopying,
recording of any information storage and retrieval system, without prior
permission in writing from the publishers.

ISBN 1-86914-104-0

Managing editor: Sally Hines
Layout and design: Julia Skeen and Flying Ant Designs
Cover design: Julia Skeen and Flying Ant Designs

Printed and bound by Interpak Books, Pietermaritzburg

Other work by Chris Mann

Poetry

First Poems, *A New Book of South African Poetry in English*, *New Shades*, *Kites*, *Mann Alive!*, *South Africans*,
The Horn of Plenty, *The Roman Centurion's Good Friday*, *Heartlands* and *Beautiful Lofty Things*.

Plays

Mahoon's Testimony, *Frail Care* and *Thuthula*.

Multi-media poetry and play productions with images by Julia Skeen

The Crux of Being, *The Horn of Plenty*, *Hildegard of Bingen*, *Heartlands*, *In Praise of the Shades*, *Walking on Gravity*
and *Beautiful Lofty Things*.

Other work by Adrian Craig

Starlings and Mynas (with Chris Feare), *Johan August Walberg* (with Chris Hummel).

Note: Translations of the names of the animals are included when the translated word is in widespread current usage or listed in reference
works available to the authors. The translations are in the following order: Afrikaans (A), seSotho (S), isiXhosa (X), isiZulu (Z).

CONTENTS

Aardvark .. 2–3
Antlion .. 4–5
Bees – *for Thomas Berry* 6–7
Blesbuck ... 8–9
Cape Robins ... 10–11
Chameleon ... 12–13
Cicada .. 14–15
Cut-worm ... 16–17
Dicynodont – *for Billy de Klerk* 18–19
Dove ... 20–21
Dragonfly ... 22–23
Eagle Owl ... 24–25
Eastern Cape Rocky – *for J. Cambray* 26–27
Eland .. 28–29
Electric Ray – *for P.T. Mtuze* 30–31
Elephants ... 32–33
Finches ... 34–35
Heron ... 36–37
Humming Bird ... 38–39
Jellyfish .. 40–41
Kudu ... 42–43
Lizard ... 44–45

Maggots ... 46–47
Mosquitoes .. 48–49
Moth ... 50–51
Mouse ... 52–53
Orthosuchus .. 54–55
Owl ... 56–57
Peregrine Falcon .. 58–59
Porcupine ... 60–61
Rhinoceros ... 62–63
Salmon ... 64–65
Seahorse ... 66–67
Sheep .. 68–69
Silverfish .. 70–71
Spider ... 72–73
Tortoise .. 74–75
Warthog ... 76–77
Worm ... 78–79
Zebra .. 80–81
Epilogue: Thornbush ... 82–83

Acknowledgements ... 84
Select Bibliography .. 84–85

Aardvark (*Orycteropus afer*)
Mammalia: Tubilentata: Family Orycteropidae
erdvark (A) *inxakhwe* (X) *isambane* (Z)

Although the aardvark is first in the animal alphabet, it is not easily added to a zoologist's life-list. My first live aardvark sighting was a young animal hurrying along its repetitive route in the night-house at Berlin Zoo. Many night-drives later, I saw my first 'real' aardvark and each encounter remains a special memory.

An aardvark in a spotlight is surprisingly big and pale, with a skirt of black hair on the flanks. When startled, it is capable of moving fast and although it appears ungainly, it is clearly powerful. In the skeleton, the huge collar-bones brace the digging forelimbs; the skull is puny by comparison, and toothless.

Finding termites is not difficult in Africa, but nose and ears also need to be alert for predators. Lions will kill and eat aardvark, yet always leave the stout, fatty tail. Is this perhaps where its strong smell is concentrated?

Flies at the entrance to a burrow are often a sign that an aardvark is in residence. Many other animals utilise aardvark burrows as a refuge, rather than do their own digging. Ant-eating chats, which share the aardvark's termite diet, always nest in aardvark burrows, building their accommodation up against the roof. Ancient and distinctive, the aardvark is a truly African experiment in evolution.

AARDVARK

Watering the garden, one hot summer night
with a full moon up and glistening the trees,
the roofs and spires of a small country town,
I started wondering where in the bush you were
and wanted to look for you, all over again.

Why I can't explain. You'd dodged me for years.
I'd lain down in a kloof at dusk, beside a burrow
whose underworld porch was speckled with flies.
The stars pricked out. Jackals wailed and went.
Nothing, not even the faintest gleam of a nose.

I'd trailed you on the web, in texts by scholars
and phoned up farmers for news of your spoor.
I'd stood like a schoolboy in a bakkie at night
and swept the Fish River thickets with a torch.
Hole after hole in termite-mounds. Never you.

Strange. You had me beat. Yet there you were,
like a vague awareness, a snuffling in my head.
I turned off the tap, and barefoot on the stoep
sat down and closing my eyes opened a space
for you to embody your absent presence in me.

I saw you then. A blur trotting through scrub.
A giant shrew. A dusty pig. Swinging a snout
across bare ground beside a ghost-pale aloe.
You paused. Pressed down your nose. Snuffled.
Flurried claws. Then licked and licked the ants.

Was it the moonlight of an ancestral Africa
or a videocam crew, making a documentary
that lit the eye gazing at me? Who knows.
You'd crossed over, into my inner landscape.
You'd visited me like a shade, and I was glad.

Antlion (e.g. *Cueta, Myrmeleon* spp.)
Insecta: Neuroptera: Family Myrmeleontidae
mierleeu (A) *unomanxelana* (X)

As sit-and-wait predators dependent on a trap, antlions need to be able to endure long fasts in hot and dry conditions. The conical shape of an antlion's pit and the angle of its sides depend on the physics of gravity and sand-grain size, with no escape for an ant once it has tumbled over the edge.

Sliding sand and scrabbling legs alert the antlion to the presence of an ant, and its sickle-shaped mandibles reach out from under the sand to grasp its prey. The ant is soon sucked dry, its internal tissues digested by enzymes secreted through the hollow mandibles and its empty exoskeleton is then discarded.

Like many other insects, antlions undergo an astonishing metamorphosis, during which their bodies are completely reshaped. Adult antlions resemble dragonflies, with four transparent wings marked by a distinctive tracery of supporting veins. However, they are clumsy fliers in comparison with dragonflies, and active mostly at night, preying on other small insects until they mate to produce a new generation of pit-building larvae.

Not all such pits are the work of antlions. There is also a group of flies (Ragionidae) whose worm-like larvae lie at the base of similar cones and engulf small insects – perhaps miniature models of the sandworms in Frank Herbert's novel *Dune*.

ANTLION

1

Your sandpit broiled in the sun.
I hunkered down, took a twig
and bent to the edge of a mine.

The sand was poised. Precisely.
A touch, and a stope collapsed,
choking the floor with its scree.

A pause. A hot stillness of sand.
Were you shuffling memories
of land-slips with *homo habilis*?

A twitch. A bulge. Then *flick-flick*,
a spray of grains spattered up,
slithering back down in a tide.

You were a mole, a whirligig,
a dust-devil. You snuck around
below a dimple, a sink-hole.

I sat and gawked at your skills.
How you could slug out a year
without a snack in a famine.

How when the summer sun
battered your sand-trap
you'd slur your cell-life down,

squeeze shut each spiracle pore
and back-absorb the moisture
barrelled in your rectal pouch.

When did you suss out physics?
Each grain was deftly perched
in a subtle, invisible matrix

of pressure, friction and gravity.
Unschooled, miles from Euclid,
you'd spaded out a perfect cone.

The poetry of nature, I thought,
bubbles up in the awe of discovery.
Science is the aquifer of the well.

2

I tensed. Tugging a wing-scrap
a glossy black hoplite of an ant
had slid backwards over the rim.

It panicked, trampling its legs
in a hot snow, until it triggered
the avalanche of its own demise.

You waited, then shoved a pair
of crab claws through the debris
and clamped it round the waist.

The forager bucked, then lay still.
I felt I watched, within your yard,
the workings of a cosmic rhythm,

the energy crunch, then transfer
that blasted a sun's mantling fire
into the dust that fleshes us both.

We were implicate life. You drank
a warm sacrifice of the nutrients
that feed the lifelines of earth,

as I who live off a cornucopia
of animals, plants and thoughts
feasted on astonishment at you.

Bees (*Apis mellifera*)
Insecta: Hymenoptera: Family Apidae
by (A) *dinotshi* (S) *inyosi* (X) *inyosi* (Z)

The abutting hexagons of a honeycomb form a symmetrical pattern common in decorations and in natural structures. However, bees are not really such precise mathematicians and the cells in which they store honey, and those used for rearing their larvae, are often very variable in shape. It is more our expectation of perfection and the frames that we provide for them in beehives, which impose a false sense of unfailing regularity.

On the combs in the hive, the dances of returning foragers can convey details of the source of nectar to a receptive audience of fellow workers.

Records from Egypt and China show that people around the world have been beekeepers for more than 7 000 years and honey-hunters for even longer.

Some Asian bees still build free-standing combs suspended from trees, which are more accessible than those in rock clefts or hollow trees, but are protected by the bees' stings. In Africa, a partnership has evolved between people and honeyguides and the birds have developed a rare ability to digest wax through the micro-organisms living in their guts.

Bees serve us well, providing honey – the original sweetener – and beeswax, as well as a pollination service, vital to many plants, especially to some that provide humans with food, such as most fruit trees.

BEES

Before we'd scratched
geometry in the sand
or baked the first mud brick
of Jericho's walls
you'd waxed a hexagon
into honeying towns.

I lay like a Gulliver
beneath your flight-path,
bewildered by the traffic
flickering in and out of your hive
and the grubs of ideas
you licked in my mind.

Did the dance-codes of bees,
you made me ask,
the algorithms of science,
the spirals of the stars
explode from a space-time nowhere,
by chance?

I tried to imagine your niche.
Its live communion
of insect, plant and soil
with the physics of space.
My vision fuzzed out
as I strained for the whole.

I tried to focus,
on the ghost-blue aloes you saw.
Your ringlets of genes.
The fish-glint of your quarks.
Each line of insight
faded in a knowing unknowing.

I shut my eyes.
Brooded in the dark sweet combs
lobed in the brain
the soft pale grub of a thought
nudged from its crib,
uncrumpling a gleam of wings.

True science,
it breathed,
*begins and ends
in mystery*

Blesbuck (*Damaliscus pygargus phillipsi*)
Mammalia: Artiodactyla: Family Bovidae: Sub-family Alcelaphinae
blesbok (A) *inoni/iblesbhokhwe* (X)

Together with its Western Cape cousin the bontebok, the blesbuck represents a distinctive southern African theme in the antelope family – long-faced runners of the open plains, with short, curved horns in both sexes. The blaze of white on the blesbuck's muzzle does not link to the white patch on the forehead and its coat colour is more uniform than the bontebok's.

Blesbuck are found on the high grasslands of the central plateau. Their numbers declined rapidly once European settlers had brought guns and horses, but they survived thanks to a late reprieve when a few farmers preserved their herds.

Twitching tails and shaking heads are intended to discourage biting insects and other more sinister flies. Bot flies may lay eggs near the nostrils, producing larvae, which burrow into the nasal passages and feed on the tissues as they develop. Snorting dislodges a few, though some may penetrate as deep as the brain, disrupting important functions.

Male blesbuck spend long periods on small territorial patches, where the grass is a short, thick lawn, well fertilised by urine and dung. Other males are chased out forcefully, or displaced in formal display rituals, while females are enticed to stay long enough for mating. Young blesbuck are coltish, pale fawn in colour, and initially lacking horns. Two straight stumps are developed later, which finally grow into the ribbed, lyre-shaped horns of the adult.

BLESBUCK

Encountered in the bushveld, during the pilgrimage of a hike,
a blesbuck's ruined cathedral.
Squatting on my heels, I stroked the transept of the pelvic arch,
the skull's buttresses and dome.

I marvelled at evolution's urge, to fodder the earth with plants
and bone an animal from genes.
I rejoiced in evolution's desire, to architect within my cranium,
language, reasoning and belief.

Then in the hush of contemplation, I saw in the thorns
a blesbuck ewe suckling her splay-legged calf.
Quietly, in the dim-lit sanctum lobed in the nave of my cortex,
the altar-candles flickered alight.

Cape Robin (*Cossypha caffra*)
Aves: Passeriformes: Family Muscicapidae
janfrederik (A) *mokhofe* (S) *ugaga* (X) *ugaka* (Z)

The name 'robin' was first applied by English-speaking settlers to birds in the new colonies that shared a red or orange breast with the European robin, although these new 'robins' included birds of several different families.

Cape robins begin their attractive song before dawn while it is still dark, and often sing in the evening after sunset. Their song is directed at other robins, advertising territory with a male in residence. Other *Cossypha* robins are skilled mimics, but only a few individual Cape robins regularly include imitations of other birds in their songs. In gardens they are familiar birds, tame yet wary.

The Cape robins' nests are built very low down, often on the ground and even in potted plants. Living close to people (and their domesticated animals) may be hazardous, but it also provides some security from predators such as rats and snakes.

Robins are frequent hosts of the Piet-my-vrou, a cuckoo whose young ensure sole occupation of the nest by evicting the eggs or young of the bird whose brood they have parasitised. So the robins' busy foraging in our flowerbeds may often benefit the parasite rather than their own offspring.

CAPE ROBINS

Before the dawn's faint grey had flushed the bush
and gleamed its hooks and fruits,
before the dusk had snuffed them out and brought its dangers near,
the robins pegged their boundaries out in song.

We heard them call and sing from perch to perch
and wondered why our house,
so blunt and stiff, without a worm or midge to dart upon,
should stand within the radius of their care.

That we should share the same small patch of earth,
yet stay familiar strangers,
that they should hear our coaxing human talk, yet fly from us,
is as our different pasts and roles ordained.

This listening to another creature's speech,
our kind or theirs, this care for privacies
that nest inside another's weave of language
ensures our beings blend, our distance keeps us near.

Chameleon (*Bradypodion* spp.)
Reptilia: Sauria: Family Chamaeleontidae
verkleurmannetjie (A) *lempetje* (S) *ulovane* (X) *unwabo* (Z)

Chameleons resemble tiny dragons, with ornamented (sometimes horned) skulls and eyes set in independently moveable turrets. Slow and deliberate movements conceal them as they stalk their insect prey, until they are within range for a rapid tongue-flick.

Their fabled colour changes are linked to temperature and mood, rather than an attempt to match the background. Nerve impulses trigger the movement of pigment in cells with branches radiating like the arms of a starfish, so that colours are spread out on display, or hidden in the central storage region. Courting males flash sparkling flanks to press their suits and threaten rivals with more sombre shades. When handled, chameleons often turn black, with gaping orange mouths.

Dwarf chameleons are the common garden species in southern Africa, and they bear live young in a transparent package, the last vestige of egg membranes. Some larger species dig holes at an unhurried chameleon-pace, before depositing a clutch of eggs.

Many rural people fear chameleons and refuse to touch them. Old legends in Africa tell of a creator who sent a messenger to pronounce human beings mortal, then relented and sent the chameleon to repeal the death sentence. But the slow-footed chameleon arrived too late and the fate of humans was already sealed . . .

CHAMELEON

Good morning, dainty dinosaur
my dragon-myth in miniature,

slowly swaying, step by step
your slender leaf-grey pod of cells,

your crib of Old World genes
along a branch, an alleyway

of air-rocked, earth-rooted,
sap-feasted, photon-lavished leaves.

Christ, chromosome cousin,
how good to see you stroll the tree!

Ag no, don't flee, don't rush away
and hide from me like all the rest.

I love your casque, your Joseph coat,
your slow-foot gait and small-frog face,

the *zap-splat-I-got-you!*
fly-culling flick-outs of your tongue

and the mech-eng epiphany that minds
those micro-telescopes your eyes.

Am I to you an ape-shape-come-lately,
a branch-slashing, bush-ashing beast?

I feel, deft-foot, sort of ashamed
that should I stretch a hand to you

your skin would blush a sepsis-black
that shrieked out, *No! No! No!*

Look, look below your perch.
Your swamp-fern foes are fossils now.

So why the hang-dog head,
that moping mouth, the Hamlet gloom?

God knows how much I wish we'd learn
never, never, never to trash the lavish tree

and fend and blend among the leaves
like you my bronze-green altar-lion, like you.

Just think, each cell inside your spine
teems with more life than any town.

And then, sweet prince, think of the stars.
Out of stardust your eyes were made. And mine.

Cicada (*Platypleura* spp.)
Insecta: Hemiptera: Family Cicadidae
sonbesie (A) *inyenzane* (X) *isihlonono* (Z)

The summer song of cicadas can be almost deafening on hot days – a single sustained note, generated by vibrations of their abdomens. Cicadas draw their energy from the sap of the plants on which they perch and are very hard to locate, as they fall silent on being approached.

Throughout the world, cicadas spend most of their lives underground as larvae. Some species of the colder northern regions may take up to seventeen years to complete their development, after which they finally emerge as adults to lay eggs and start a new generation.

The tracks of cicadas can sometimes be found on coastal dunes. Often a shed skin still clinging to a grass clump indicates that the owner has moved on in new, larger attire as a winged imago.

Like other ancient animal groups, cicadas reveal links between the southern continents. They are not great travellers, and do not fly far. So the relationships that entomologists are discovering between cicadas on the southern continents are likely to reflect an ancient pattern, fragmented when Gondwanaland broke up and populations were isolated on different landmasses.

CICADA

You sing your heart out, from a milkwood dune
swooning with berries
in the hot quivering air of a mid-summer's day.

I hear the same song in the sighs of lovers,
a child at the breast,
the beggar by an alley, the priest at the grave.

You sing on and on, of the life-long desire
to love and be loved,
of a wisp of star-dust, a twist of genes.

Cut-worm (a group, rather than a single species or genus)
Insecta: Lepidoptera: Family Noctuidae
snywurm (A) *umbundane* (X) *umswenya* (Z)

Gardeners are often infuriated to find young seedlings severed at the base, cut down before they have had a chance to develop. Cut-worms represent a guild of larval insects that feed in this way and the most familiar ones in South Africa are moth larvae, which hide underground and emerge at night to feed.

Their tunnels may help to aerate the soil, but other animals such as earthworms do this better, without demolishing plants along the way.

As adults, cut-worms are small, dull-coloured moths that lay their eggs on plants, from where the larvae hatch and crawl down to burrow into the soil. These subterranean larvae are prey for hoopoes and other birds, which feed by probing their beaks into the soil.

Underground, they may be pursued by slender burrowing snakes and lizards and also by golden moles. These little insect-eating diggers have an iridescent sheen on their fur and shovel-shaped claws. They are unrelated to the 'true' moles of Europe and seem to be among the most ancient mammals that have evolved in Africa.

CUT-WORM

For crying out aloud, big mouth, not again!
My tender green grove of spinaching sprouts
all nibbled round the base and felled. Felled!
Felled and forsaken in rows for what? Logs?

It's over, molekin. Don't even try to wiggle
your soft plump sack of chubby innocence
back into the tumulus saying, *It's the genes.*
Why can't you adapt, to life in the suburbs?

I tried. I really did, Orpheus. To rescue you
from a fairy ring of toxins around each sprout
and death by a lingering, inward liquefaction,
I dug so much compost into your underworld

my neighbour said, *That's un-Darwinian, pal.*
I opened a dive, a basement club in the soil.
All you had to do was pack the place with kids,
open wide and chew. Ja, that's all fella. *Chew.*

We could have been mates. Partners in Agric.
You airing, me mulching our vegetable Eden.
Ag no, my grub-nub, our times are out of sync.
Millennia must pass, must pass before mutation

pops out that quirky kid, that ridiculed genius
with mad ideas, the blood-line's new Messiah.
I'm sorry. I really am. I'm also a munch-head,
a vulnerable, brief-lived bag of tricks like you.

This here's a spade. Call it Natural Selection.
To cull my competitors. Till your lot and mine
wise-up our relationship. Till Gaia comes back.
Bring on the future! The insect rights and parks!

Right now – it's me, kindred worm. Or Thou.

Dicynodont (*Aulacephaladon baini*)
Reptilia: Synapsida: Therapsida:
Family Dicynodontidae

Formerly a wet, well-vegetated inland basin, today the Karoo is dry and hot and fossils bake in the sun where dicynodonts would once have wallowed in swamps. *Aulacephaladon* was a rather pig-like animal, about the size of a hippo. Track-paths of extinct animals are rare and those found by Billy de Klerk and other palaeontologists give us a new insight into the lives of these creatures. Now we can add gait and pace to the anatomical reconstruction of the skeleton and restore movement to a frozen image.

South Africa has an extraordinarily rich fossil record of synapsids, a reptile group that represents the origins of mammals. Within this radiation, the dicynodonts were lumbering vegetarians, often almost toothless with a beak-like mouth similar to a tortoise's, but generally with two tusk-like canines projecting downwards from the upper jaw.

They date back to a time when the southern continents were united as Gondwanaland, with Antarctica well clear of the South Pole.

South African palaeontologists searching the exposed sedimentary rocks in Antarctic valleys soon identified fossils of *Lystrosaurus*, one of the dicynodonts that defines a geological time-zone in the Karoo system. *Lystrosaurus* was a doughty survivor, one of the few synapsids that persisted after the great Permian extinction 250 million years ago.

DICYNODONT

Brushing the rock-spoor of a heel,
an up-squeeze between two claws,
I sense you, plodding across a vlei.

I bend closer, puff dust out valleys
and lose the pattern in the details,
in a vinegary smell of preservatives.

I raise my head. A silence of scrub,
tortoises, bedrock. My mind-sight
scans a palimpsest, the Great Karoo.

I try to place your track-site in time:
a flood-plain, with Antarctica's peaks
still visible, still groined into Africa.

Silence. Heat-warp. Nothing moves.
Suddenly I see you – grey, plodding,
toiling your mound through rushes.

You splosh past ferns and algae mats,
a pug-nosed boar, a sea-lion on legs,
a new noun stomping into my lexicon.

I sense a bowel, gurgling with tannins,
rumples of leg-hide, your hippo's knee
and clawed foot, raised up into the air.

You're poised, ready to print a cipher
on time's Rosetta-like parchment of mud.
Your foot smacks down. Then comes

the fixative of earth and mind,
the *squish*.

Dove (Cape Turtle Dove) (*Streptopelia capicola*)
Aves: Columbiformes: Family Columbidae
tortelduif (A) *leeba* (S) *ihobe* (X) *ihope* (Z)

In South Africa, the Cape turtle dove is an almost ubiquitous sound and is often heard on the soundtracks of films set in southern or eastern Africa. Fortunately it can be heard all year round in these regions and is thus seldom out of context to an ornithological ear.

Altruists describe the call as 'Help father', while cynics render it as '*Werk stadig*' (work slowly), especially in the middle of the day when the heat-haze shimmers. Common in habitats modified by people and in even drier areas than other urban doves, it seems able to cope with humans' impact on its natural environment.

Like all doves, the Cape turtle dove seems careless in its breeding habits. Two pure white eggs are laid in a sketchy nest of sticks, with no attempt at all at concealment. However, because it is not restricted to a narrow breeding season and breeds often, it flourishes, taking full advantage of the extra food that people provide through planting grain and discarding food scraps.

Another characteristic of all members of this bird family is the production of 'pigeon milk'. This is a nourishing liquid formed by cells lining the throat and is fed to the young squabs, especially in the first days of their lives.

DOVE

You were murmuring before I woke.
I lay in bed with my eyes still shut
and half-asleep, listened and listened.

Outside the room – voices and traffic,
the green-leafed raftering of a tree.
I kept still, trying to hear more of you.

'Ku *kuu*-ru, ku *kuu*-ru, ku *kuu*-ru.'
I let your language seep into mine,
drinking it in like a Latin or Greek.

Then heard you sing in Virgil's lines,
when he sees you 'gliding' in Rome,
and in Matthew's verses where you

break out of the hot bare Jordan sky
and hover around the head of Christ.
You throbbed, throbbed into my thoughts

a logos as ordinary, as quietly insistent
as the innumerable small acts of love
that nurture a marriage, or parent a child.

Dragonfly (*Anax* spp.)
Insecta: Odonata: Family Aeshnidae
naaldekoker (A) *uhlabamanzi* (X) *uzekamanzi* (Z)

Dragonflies are among the world's oldest flying creatures, with fossils dating back to the era of the great coal deposits in the northern hemisphere – the Carboniferous period, 200 million years ago.

With huge eyes and four long wings, they are skilled fliers, gathering in insect prey, which is thoroughly 'outgunned' in aerial combat. Able to hover, reverse, and zip forward at speeds of three metres per second over short distances, they are wonderful aerial hunters. Often they defend a stretch of water against rivals of their own species, or even other dragon- and damselflies, thus showing territorial behaviour more familiar among vertebrates.

The larvae are also formidable predators, lying in wait at the bottom of ponds and streams. They have extensile jaws like snap-traps to engulf passing swimmers, including tadpoles and small fish. They can move very fast, jet-propelled by water expelled through the anus.

Today dragonflies have a new significance in ecology, since their presence is a guide to the health of our streams and wetlands. There are relatively few species, which are readily identifiable, so amateur dragonfly-watchers can play their part. Mapping their distribution on a local scale can quickly reveal problem areas, where a low population indicates that pollution has poisoned the water.

DRAGONFLY

Your lineage is as old as coal, your life, in the swirl of stars,
a twitch of plasma on a reed.
Rafting down the Zambezi, I saw your filigree shimmer
on a boulder's bulky sphinx.
The raft had spun in an eddy, bumped the wall of a gorge
and grounded on a spur of rock.

I was glad to rest. Upstream, a vortex in the slide of green
had slid the raft to its crest,
lifted the stern high in the air then hurled me from my bench
down into a roaring, spinning hole.
For a whole eternity of panic I'd suffocated in a Charybdis,
feeling certain that I'd drown.

How greedily then I registered the powdery, glistening bands
of crimson around your back,
each wingtip's lunette of blue. I dipped a finger in the river
and on the hot, eroded granite
wrote my name in water. Before I'd streaked the last letter,
you and the writing had gone.

Eagle Owl (*Bubo africanus*)
Aves: Strigiformes: Family Strigidae
ooruil (A) *lerivise/sephoko* (S) *isihuluhulu* (X) *isikhova* (Z)

The spotted eagle owl is present in towns as well as rural areas and will often nest on the ledges of buildings. Unfortunately owls have failed to adapt to road traffic and often end up as road-kill, their sensitive eyes dazzled by the headlights of an approaching vehicle.

Rats and mice, their main food, are found everywhere and urban owls may also take advantage of street lights, which attract large insects. Indigestible bones and chitin are ejected in pellets, which give us a good idea of the owl's diet.

It seems incongruous that efficient killers such as owls should be popular toys and ornaments, yet the direct stare of their eyes and the facial disc and ear tufts detract attention from the hooked bill and powerful predatory feet, which are partly hidden in the dense plumage. These feathers muffle their wing-beats and their silent flight is a great asset to a nocturnal predator, but can be very disconcerting when an owl swoops close to human beings.

Many owls can locate prey accurately by sound alone and the rustling of mice is loud enough to betray their presence to a hungry owl.

EAGLE OWL

You terrified me from sleep.

I'd gone off into the night,
a ruminant of Africa's stars,
and lain down in the grass

that wet the Hashaza hills,
my hitchhiker's rucksack
pillowed under my head.

Whish! I woke with you
hovering your dark angel
between me and the moon.

Your pinions smashed air
across my face. I leapt up,
yelling, flailing my arms.

You sped off, and left me
quivering with a revelation.
My genes like Jacob's ladder

were grounded in the earth.
Their spiral twists of rungs
reached up into the stars,

into the genesis of space.

Eastern Cape Rocky (*Sandelia bainsii*)
Osteichthyes: Perciformes: Family Anabantidae

Endemic to a limited area of the Eastern Cape, this little fish is now endangered through the impact of humans on its environment. Otters and piscivorous birds are natural predators, but the real threats to the Eastern Cape rocky's existence come from introduced predatory fish (such as bass), alien plants that choke and deoxygenate the streams and run-off from cultivated fields adding silt and chemical supplements to the brew.

Biological control of water weeds now relies heavily on imports of natural insect enemies from the source countries of these plants, so South American weevils as 'knights errant' protect the habitat of South African fish.

Unfortunately *Sandelia bainsii* is not a charismatic animal like an elephant or a cheetah and is of no economic value as food, or as an ornamental aquarium fish. Its champions are the dedicated few who see its demise as a loss to the diversity of the world that sustains us.

The scientific name commemorates two important figures from the Eastern Cape region: the Xhosa leader Sandile, and Andrew Geddes Bain, pioneer and road-builder – contemporaries and antagonists, united in this living memorial.

EASTERN CAPE ROCKY

Isn't that thumb-small silvery corpse
belly-up in the reeds one of you?
I hope he isn't expecting a requiem mass.
Or a cairn with a plaque.
Jeez, it's not that uplifting
watching a species gasp to its end.

Maybe the otters did you.
Maybe that feathery hit-artist, the fish-eagle.
They chow you and yours
like you chow spawn and larvae and things.
Eat or be eaten. Adapt or – exit.
Doesn't Bishop Darwin's creed apply?

The man with the fishnets,
gumboots and clipboard says it's our fault.
The bank rate's up. So the farmers plough
the river banks under, to plant more crops.
To pay higher bonds, fuel-costs
and school-fees. To buy slurpier pumps.

So bye-bye, clean rivers.
And howzit, phosphate run-off in lungs.
That's not the sweetbread of poetry.
Sure. But nor is croaking like a quagga.
Ag, sorry – I'm just being human.
Blaming someone else. Thinking to improve.

Take the green stuff smothering your pool.
A floating sundeck. It's from Brazil.
Nice, hey. Must be like breathing
with a wet sack draped around the gills.
Bought in a pet-shop, for someone's angel fish.
Then snuck down a drain, into the streams.

Now people are going mad
with pangas, sprays and imported bugs.
Blame the Customs Officials in Durban
and Rio. Blame the pet-shop
and banks. Blame farmers with ploughs,
the markets, Mesopotamians and Adam.

It's that tangled up. And scaring.
Who got you into this dead-end but us?
The man with the gumboots and nets
is lifting you gently with callipers into a flask.
He's the hell in with humans.
He wants to educate us, put up fences

and Save the Species. He's a hero.
A dreamer. Don't humans foul their nests
till someone rubs their noses in it?
Please turn meaty, pal. Or purple.
Right now you're too thin for catfood.
Too drab to be a pet-shop freak.

Eland (*Taurotragus oryx*)
Mammalia: Artiodactyla: Family Bovidae: Sub-family Boviinae
eland (A) *impofu* (X) *impofu* (Z)

Eland are the largest African antelope and are often found in montane areas. Old bulls are grey, with heavier horns and woollier heads than females or younger animals, with ponderous bulls weighing as much as 700 kilograms.

Eland were not merely a source of meat for the San people, but also an important symbol in the trance dances, during which the shaman might transcend his human form and take on the life of another animal. Thus eland are depicted in rock art throughout South Africa, and their images have provided important insights into the magical beliefs of a culture that later human arrivals did their best to exterminate.

Superficially as placid as cattle, yet better adapted to life in southern Africa, eland have been tested as 'domestic' animals, even in a long-term study at an agricultural station on the Ukrainian steppes. Their milk is much richer than cow's milk, but it needs to be modified for human consumption. In general they seem better suited to game ranching than intensive husbandry.

ELAND

I watch you in my memory.
From the hide in the brain
where micro-amp shimmers
holograph a bushveld, a vlei.

You lift a dripping muzzle
from a mud-brown glisten,
step off and stand head up
hardly moving in the scrub.

Nothing happens. Slowly.
A breeze strokes the reeds,
then collapses. A faint dot
floats away above a ridge.

I feel myself being pulled
inside a landscape, a time
shaped in my palaeo-cortex,
a trance that is stone-age.

Squeezing my eyelids tight,
I watch you quiver a flank.
You seep a vigilance, a calm,
an antelope strength into me.

A haunch as tawny as grass,
a twitch of tail dim to blurs,
to a granular masonry beige
as of sandstone in a cave.

The shaman in me grows.
With spittle and red ochre
I trace a line of stick-men
then smear you in pale clay

soaring above their dance
as potent as a rain-cloud,
as a force-field of energy.
From a past to present art

you leap clear of my brain.

Electric Ray (*Torpedo* spp.)
Chondrichthyes: Family Torpedinidae
drilvis (A)

Lying on the sandy bottoms of lagoons and estuaries, electric rays respond to disturbance by an ill-placed foot with a discharge of electricity from modified muscle cells, which is strong enough to stun the small fish on which they feed. These sudden shocks can release up to 220 volts of stored electricity for defence or predation.

All living cells produce electrical phenomena, which some fish exploit to generate their own electricity, whereas others have developed systems to detect electrical activity.

Some African fish living in turbid waters maintain an electric field around their bodies and so feel their way by detecting distortions of the normal pattern. Magnetic fields modify electrical activity, so that sharks may use their electric senses to navigate across the ocean by means of a magnetic compass, with any deviation from the right course marked by a jangle of electrical anomalies.

They can also detect hidden prey, betrayed by an involuntary electrical aura. Several groups of freshwater fish communicate with others of their kind by modifying their electrical output. A courtship song of fluctuating electrical currents seems far removed from the more familiar courtship rituals of our world above the waves.

The *impundulu* in the text refers to a mythical creature from Xhosa culture, often interpreted as a harbinger of misfortune.

ELECTRIC RAY

Foam-crested waves, seen in an estuary
as I swam a slow river. And dove-song
heard across water from thickets of thorn.

Floating in the Fish, one simmering noon,
I porpoised on my back, closed my eyes
and lazed in a lavish green glitter of brine.

I drifted in silence. My eye-lids swarmed
with the red of a poppy, of a Chartres rose,
with sunlight adored from inside the blood.

I spread my arms out wide, and breathed.
This was the Cambrian, the amphibian me,
the mud-puppy, the rock-pool algae basking.

This was immersion in a Ganges, a Jordan,
the mind's restlessness rivered into a bliss
as real as the taste of the sea on my tongue.

What was I to you, whose muscled undulance
of wing and tail lay mudded among prawns?
A gloom, a shark-shape in a ceiling of light?

I waded across the sand-bank, loving the feel
of silt slushing between my toes, of hot sun
parching the wet on my back to rinds of salt.

Ahhhh! A burning agony exploded in a foot.
I leapt off, clutching water, desperate to flee
your nest of scorpions, your barrage of quills.

Did you panic as I did, as you flapped to sea
in puffs of silt? I felt I'd stepped on bare wires,
on *impundulu*, the trickster, the lightning-bird,

on a river of slumberous energy's dark spines.
I scrambled ashore – to cattle, fencing, a road.
Sitting in the sedge, I rubbed my instep in a daze.

Elephants (*Loxodonta africana*)
Mammalia: Proboscidea: Family Elephantidae
olifant (A) *tlou* (S) *indlovu* (X) *indlovu* (Z)

The legend of elephants' graveyards has a long tradition in Africa. Yet even these massive carcasses decay and the bones are chewed and scattered by scavengers. Elephants can attain the 'three score years and ten' supposedly allotted to human beings, before their final molar teeth fail and they die of starvation.

Individual animals have long-term associations and the death of a companion clearly disturbs the survivors, but most natural deaths are isolated events. Only gunfire is likely to eliminate a whole group so that their bones form a pile. Elephant herds are groupings of females and their young; bulls associate with them at times, but usually form their own smaller units.

Old matriarchs are the leaders, whose long experience and knowledge of senior members of other herds is reassuring to both parties when they meet. Thus the death of a matriarch has wide-ranging consequences for elephant society.

Trumpeting is the noise we usually associate with elephants and we have only recently begun to appreciate the importance of low-frequency sounds in elephants' communication. Once called 'belly-rumbles', these emissions can be transmitted over many kilometres with little distortion and may be significant to neighbours as well as to animals in the same herd.

ELEPHANTS

Some place in deepest Africa
it's said there's a valley strewn with bones,
where ribs, skulls and chunks of vertebrae,
like monuments of pumice stone,
lie scattered among the thorns.

Old-time hunters with grizzled necks
would tell this tale beside a fire,
that elephants would shuffle there,
would trumpet one last time
then slowly topple over among their kin.

Those hunter-types are in their grave
and yet the legend lingers on,
for elephants are ponderous,
likeable, anachronistic creatures,
and where better than Africa
can old romantic idealists go
to lay their creaking structures down?

'Finches' (Cape Weavers) (*Ploceus capensis*)
Aves: Passeriformes: Family Ploceidae
vink (A) *talane* (S) *ihobohobo* (X) *ihlokohloko* (Z)

In rural areas, 'finches' or *vinke* are the generic common names for seed-eating weavers, which are often very destructive in wheat-fields. One of the first biologists to stay for several years in Africa was the French botanist Adanson (after whom the baobab is named). Adanson reported how in Senegal in the mid-eighteenth century, yellow and black weavers were a major pest of cereal crops, necessitating ingenious scaring devices strung across the fields. Letting young boys loose with catapults, pellet guns, or even small calibre rifles, was a typical approach to controlling their depredations on South African farms.

Whereas most indigenous birds avoid the groves of gum trees (eucalyptus from Australia) commonly planted on farms, weaver colonies are often found suspended from their branches, especially near homesteads. However, snakes such as the agile boomslang are major predators of nestling birds.

Adult Cape weavers can be long-lived – one male bird was recently recaptured at the same site where he had been ringed ten years before. However, where the *vinke* rank as pests in the wheat-growing districts of the southern Cape, nesting near the house will reduce their lifespan, even if snakes are kept at bay.

FINCHES

To think that we slaughtered
finch after soft-bodied finch
without a shrug of remorse.

Two barefoot boys on holiday,
with pellet-guns, khaki shorts
in a gum plantation on a farm.

The birds fed in the wheat-lands.
They chattered from the branches
in a din, an epidemic of hunger.

I can still remember the warmth
and the scrabbling of the claws
of one I wounded in my hands.

Twisting its head off I sensed
the skull *rrrik* from the spine.
I felt sickened, then confused.

Come *on*! said the other boy.
To him, the son of the farmer,
birds were predators in a war.

We went on killing till dusk.
That feeling I now hug close
as a growing pain, a blessing.

Heron (Grey Heron) (*Ardea cinerea*)
Aves: Ciconiiformes: Family Ardeidae
reier (A) *seotsanyana* (S) *ukhwalimanzi* (X)
indwandwe (Z)

The grey heron is the tall, solitary fisher most often seen on dams, rivers and estuaries. Its main prey is crabs and fish, although like the black-headed heron, it will also hunt rodents in tall grass. This same species occurs throughout Africa and Europe.

Shakespeare wrote disparagingly of one who could not 'tell a hawk from a handsaw'; in the falconry jargon of his day, the 'handsaw' was the heron, a great challenge for a hawk to bring down.

Characteristic of all herons is the retracted neck in flight, bent back in an S-bend, whereas storks and cranes fly with their long necks extended.

Herons have slow, heavy wing beats as the birds return to their treetop roosts in the evening. In the Eastern Cape, heronries may be found in towns, coating the trees with white excreta and often finally killing them. Harsh squawks and clattering bills accompany their quarrels and their courtship.

HERON

Each dawn you quietly paddle
the long-beaked hull of your boat
above the Atlantis of this town.

The streets and houses are still
as if they lay in a hundred fathoms.
The air is my empyrean, your sea.

You'll beach in a wetland of plenty
and load the hold of your gizzard
with meat, crustaceans and fish.

And then, at dusk, turn your prow
and silently row your vessel home.
Standing on a lawn drowned in light

I lift my head and watch your keel,
your oar-strokes pass over the trees.
How can I figure you but in speech?

In semblances, such as *lone wader*
or *wings grey* from which you glide
untouched and always your self?

Soon you'll dock at your quay.
Watching you row into the dusk
I feel like the shade of a shaman

who stands in the emptied streets
of a sunken Aegean civilization
and hears faint sounds of commotion

and does not know that above him
a ship is travelling across the sea
with St Paul on his way to Greece.

Hummingbird (Ruby-throated Hummingbird) (*Archilocus colubris*)
Aves: Trochiliformes: Family Trochilidae

Hummingbirds are nectar-feeders native to the Americas and quite unrelated to the African sunbirds; their skeletons in fact reveal a kinship to swifts. The hummingbirds include the smallest birds of all, weighing as little as 2.5 grams – an astonishing miniaturisation of all that makes up a bird.

These birds truly hum as they hover in front of flowers, their wings a blur as they beat up to 300 times a minute. Their iridescent plumage produces dazzling colours through the reflection of light by internal structures within their feathers. In an era before conservation restrained profiteering, thousands of tiny specimens were exported to decorate homes and hats.

The ruby-throat moves north as far as Canada in summer and then migrates south to follow the flowers, crossing the Gulf of Mexico to South America.

Most migrant birds navigate primarily by visual cues, though this has not yet been tested in hummingbirds. Yet it seems that birds may have to learn to use the day- or night-lights of the sky for guidance, starting out with an inborn magnetic compass to set their bearings. This sense may be housed in the eyes, since the visual pigments change their chemical behaviour under the influence of magnetic fields.

HUMMINGBIRD

I'd read about you, crossing the ocean.
The faint smudge of a southern galaxy
glimmered in my stoep to an African sky

and yet I could see you, a blur of wings
flying from a north to a south America
across the Gulf of Mexico's orbed blue.

Your speck of an aircraft yaws in the wind.
Behind you, Florida's long green coastline
sinks like a memory of spring below the sea.

You're a mite, a seethe, an eagle of desire
for the meats, the nectars of a destination
that instinct keeps hungering you towards.

You whirr onwards, as stars stipple out,
as the sea glooms beneath your odyssey,
your Theresa of Avila's arrowing prayer.

In front, huge hulks of cumulus loom up.
I groan in my bed, horrified to remember
you're navigated by the sun and the stars.

I cherish you then, your creaturing of hope,
your sacerdotal plumage of emerald green
buttoned at the throat by a blood-red jewel.

Your yearning shivers straight into the cloud.

Jellyfish (*Rhizostoma* spp.)
Cnidaria: Scyphozoa: Family Rhizostomidae
medusa (A)

The transparent beauty of a jellyfish is only apparent when we encounter the live animal in the sea, not as a beached blob covered by scavenging plough snails.

In most species of jellyfish, the stinging cells that fringe the bell, the tentacles and the column around the mouth, are used to paralyse small prey rapidly. There are small cubical jellyfish in the Pacific whose stings can be fatal, but none of the South African species are dangerous to people. Our most common and largest representative, *Rhizostoma,* lacks tentacles and stinging cells, and merely filters tiny organisms from the water that is taken up into the mouth chamber.

Jellyfish lack gills, with individual cells absorbing oxygen from the surrounding water. They digest their food in a stomach chamber lined by specialised cells, but lack an anus. Radial canals form a distribution system.

Like many marine animals, jellyfish shed eggs and sperm into the water at particular times, co-ordinated without the sexes ever meeting for courtship. There is often a sessile anemone-like stage, before free-floating disc-shaped creatures are released, which finally grow to adult-size jellyfish.

JELLYFISH

Swimming back to the beach
I glimpsed, broaching a swell,
a rubbery, translucent dome.

I paused, treading deep water.
Your sea-craft lolled, floating
between me and my habitat.

Your frill-skirted bulge rose
and sidled with the grace
of Picasso's muses on a beach.

I dallied, playing with names.
Whoosher. Squidgling. Bloop.
I struggled to shape my tongue

to words that would embody
your languid, watery bulk.
Peduncle. Endoderm. Sac.

Your gelled interior took shape,
the ghostly Venice of its canals.
Imagining your waft of fibrils

ingesting their plankton gruel
and drizzling invisible eggs
I marvelled at your delicacies.

You lived and breathed the sea.
My gills had branched into lungs.
Rounding you, I swam to land.

Kudu (*Tragelaphus strepsiceros*)
Mammalia: Artiodactyla: Family Bovidae: Sub-family Boviinae
koedoe (A) *tholo* (S) *iqhude* (X) *umgankla* (Z)

Common in the Eastern Cape bushveld, kudu are shy and nocturnal where hunted, yet soon relaxed and easy to see in protected areas.

Wonderful athletes, they can clear a standard farm fence effortlessly from a standing start and protecting a vegetable garden from their nightly visits necessitates a fence height beyond any high-jumper. Unfortunately moving headlights at night can induce kudu to leap into the road, with potentially fatal consequences for both the antelope and the occupants of the car.

Kudu bulls with their corkscrew horns are favourites with trophy hunters and in the hunting season, this provides a small industry for venison butchers and taxidermists.

Seen head-on, the hornless females and young with their narrow necks, leave an impression dominated by their great direction-finder ears. As they flee an intruder, they flash the white hairs below the tail, a striking contrast with the grey camouflage of the coat. This signal is common to many antelope and to deer (defined by the antlers which they shed each year), another example to naturalists of a simple, effective message that has developed across unrelated groups through the tinkering of evolution.

KUDU

You were staring at me, from a plaque on the wall,
as I put my glass down on the bar and turned to go.

Your head and the long straight curls of your horns,
all the tall-shouldered, tail-whisking life-art of you

had been sundered in the bush and put on display,
between a dartboard and an ad for whisky in a pub.

I walked across and ran my hand around your neck.
Your throat was still a bristled, bush-cleaving prow.

I could see where they'd stitched your lips together,
and the white and tan whiskering of your eyelashes.

There was a cardboard edge where the tip of an ear
had opened like an old worn wallet along the seam.

I remembered your kin, one dusk as thunder boomed,
leaping a barbed-wire fence stretched across the veld.

They were lithe and magnificent in their athletic grace
and mythical to me in their wary disdain for my kind.

Your eyes were staring across the green baize table
as I stood in the door. They are still staring at me now.

Lizard (Cape Skink) (*Mabuya capensis*)
Reptilia: Sauria: Family Scincidae
akkerdis (A) *mokgodutswane* (S) *icikilishe* (X) *umbankwa* (Z)

In gardens, especially on rockeries, lizards hunt insects and rush at rivals to expel them from their territories, areas as exclusive as our private, fenced properties. When active, lizards are far from cold-blooded, using a regime of sun-bathing and then sheltering in the shade to maintain a body temperature that is often higher than our own.

Skinks are round-bodied lizards with rather short legs and small eyes. They look predisposed to burrowing and there are legless, blunt-tailed species that have adopted this lifestyle. Their mangled bodies are sometimes brought in by gardeners, who have mistaken them for snakes and killed them.

Lizards and snakes are near-relatives, with anatomical features in common that they share with no other animals: for example, the males have paired structures called 'hemipenes' in their tails, which are used one at a time to transfer sperm to the females.

Garden skinks lay eggs, yet some mountain-dwellers give birth to live young, which are nourished by a placenta during their development. Where the soil stays cold for long periods and eggs might never hatch, bearing live young has evidently evolved independently in a number of different reptile groups – another example of the infinite adaptability of some animals.

LIZARD

Sprawled in the shade with a book
I lifted my head and noticed you,
snake-snout, staring across a rock.

You were dwarfed by a red hibiscus.
I could just make out your fingers,
the brown-gold lustre of your skin,

and the tiny rapid *plip-plip, plip-plip*
flickering your flank as you breathed.
I remembered a locust's spined legs

jerking in the pincers of your jaws,
the rival you stalked like a leopard.
You were a Pharaoh in your domain,

a thirst of reptile blood for the sun,
an alpha-in-omega of a gene-strand
hundreds of millions of years alive.

Do you encrypt images of sponges
and trilobites? Of what first quivered
when earth was as dead as the moon?

I thought of your life-long intimacy
with the silent guile of bush-snakes,
the raw chemistry of drought and rain.

I raised a hand, to swat a mosquito,
and you, my crocodile of the rocks,
my bird-nerved cousin, skedaddled

into a rock-cleft, a memory of you,
like a garnet-brown flicker of light,
a lickety-split shimmer over stone.

Maggots (Flesh flies) (*Chrysomya* spp.)
Insecta: Diptera: Family Calliphoridae
maaier (A) *diboko* (S) *inundu* (X) *impethu* (Z)

Flies typically lay their eggs on rotting material, either animal or vegetable, where the maggot stage feeds until it pupates and transforms into a winged adult.

Flesh flies are quick to recognise death and often lay eggs on an exposed corpse within minutes of its appearance. This phenomenon has created a field of research known as forensic entomology, which uses the insect fauna on a dead body to estimate the time of death in criminal investigations. So the niceties of how long after death particular insects appear, and the growth rates of maggots under different environmental conditions, are studied in laboratories where a tolerance of stench is a necessary evil for all participants.

Even large mammal carcasses can soon be reduced to heaving masses of maggots, all scrambling for the last vestiges of edible material. Along with bacteria, they may complete the task of disposal without the assistance of large scavengers such as vultures. Some flies do not wait for death and lay their eggs on open wounds.

The maggots may then play a useful role in removing putrefied flesh, and even today they are sometimes introduced deliberately for this purpose. They cauterise more precisely, and with less incidental damage, than a surgeon's instruments.

MAGGOTS

Turning compost, I stuck the fork through sodden kikuyu grass-rot
and lifting saw, limp on the tines, a rat's wet-furred, riven carcase.

Maggots swarmed in the intestines, pale, pudgy, like muscled nozzles,
like a litter of mouth-eyed pups humping and burrowing the maw.

The stench was nauseating. I bent, wrestling revulsion, and marvelled.
The carrion nurseried renewal. Its cleaners were spawned by decay.

Toothless, they spewed a subtle spit that foamed their meat into a broth.
They were the Greeks' sarcophagi, the listening that eats up sorrow.

I heeled the carcase off the fork, held in my breath and bent to stroke
the cherub worms of metamorphosis, which soon would chrysalis – and fly.

Mosquito (e.g. *Aedes, Anopheles, Culex*)
Insecta: Diptera: Family Culicidae
muskiet (A) *monwang* (S) *ingcongconi* (X) *umiyane* (Z)

The high-pitched wing-hum of a mosquito has ruined many nights already hot and restless. A mosquito net keeps the biters at bay, although the sound still intrudes and can keep one awake.

Few land vertebrates are not attacked by a female mosquito of some species, seeking a blood meal before she lays her eggs. The itching aftermath of the bites and the loss of blood are usually not critical, but many mosquitoes are also the vectors of disease. Along with their saliva, they inject the virus of yellow fever, the sporozoites of the single-celled malaria parasites, and the tiny roundworms of elephantiasis.

Male mosquitoes take in only plant juices if they feed at all, but in the war against their species they have been trapped and sterilised, swamps have been drained, and insecticides poured on their haunts until these poisons in turn posed a threat to humans' health.

Humans are not the only victims; the native birds of Hawaii were devastated by the introduction of foreign mosquitoes, and with them avian malaria, which had not reached the islands before. The struggle continues, as mosquitoes develop resistance to frequently used poisons, and the parasites become resistant to the drugs used to treat malaria.

MOSQUITOES

Night after night they stalked bare skin,
hovering their helicopter assault-craft
above our sheets and newly-wed bodies.

Don't you recall the din of their attacks,
the stench of the insect repellent sprays
that smothered the musk of our desire?

Roused at midnight, I slapped my neck
and rubbed the prick-holes of a vampire
that hung on the wall, bloated with blood.

I sat up, lit you with the torch and saw
a trio of grey-black oil-rigs, plundering
the calm oceanic energy of your breasts.

Fretting next morning like a bowerbird
I bolted curtain-rods together and raised
a bright brass framework round the bed.

You stitched together metres of muslin
and draped the frame in pale white veils.
We fastened a palm cross to the bed-head

and passioned and slept, at last in peace.
Our foes still hovered, but in a wilderness
outside the ark of the covenant we'd made.

Moth (a large and diverse group of insects)
Insecta: Lepidoptera: Families Geometridae, Noctuidae
mot (A) *tshwele* (S) *uvivingane* (X)

Butterflies and moths share the characteristic of scales covering their wing-surfaces and they all feed on nectar from flowers, or other fluids, through an extensile proboscis.

In Africa they differ anatomically in that only moths have structures linking the fore- and hind-wings. An easier distinction for most observers is that moths are usually active at night, and they have feathery or tapered antennae, whereas butterflies fly by day and their antennae usually have swollen, club-like tips.

Moths place their eggs on appropriate food plants, protected by shells, which are sculpted into patterns that we can sense by touch.

Certain wasps paralyse lepidopteran caterpillars by stinging them in order to provide living food supplies for the wasp larvae. Wasps do not hunt adult moths, but the predatory robber flies (Diptera: Asilidae) include some remarkable wasp-mimics, and this was surely what the observer in the poem witnessed.

Mimicry in insects comprises two main forms, named for the entomologists who described them: Batesian mimicry involves a harmful or distasteful model, which is then imitated by inoffensive creatures; Müllerian mimicry occurs when different distasteful or dangerous animals have similar coloration, like an internationally recognised traffic signal.

MOTH

I'd gazed at you in a microscope.
Your wings were scaled. Each scale
was etched and refracted the light.

You were a hologram that flew,
a soft catalyst of life, smearing
the pollens that fertilise renewal.

I loved your lichen-grey glimmer,
the thread that uncoiled for nectar
down the long cool flagons of lilies.

How I'd winced, when on my knees,
peering at the shale around an aloe,
I'd seen a wasp astride your thorax.

She too was an art-work of photons,
her wing-shimmer, her dark fuselage
a bio-tech harrier's, equipped to kill.

She airlifted your food-bale away,
making me wish animals could be
as airplants, as angels and eat the light.

Your carcase earthed my imaginings.
'Moths live Christ's mystery,' I thought.
'You incarnate, coz, how every mouse

and microbe of energy's live matrix
creates and sacrifices to the whole.'
I fingered the lichen where you'd lived,

the eloquent Braille of your eggs.

Mouse (Striped Fieldmouse) (*Rhabdomys pumilio*)
Mammalia: Rodentia: Family Muridae
muis (A) *tadi* (S) *unocwethe* (X) *imbiba* (Z)

Mice and rats have lived with human beings throughout history, shared our ships and voyages, and carried plagues that have devastated societies. Both the human and the mouse genome have now been enumerated in full, revealing some surprising similarities. Mice even share with us the genes that enable human speech, although they are apparently never activated in mice.

The striped fieldmouse is an endemic species, which may enter houses to take advantage of the shelter and food that we provide, but is not a regular house-dweller in Africa.

At some picnic sites in nature reserves, it will scurry about at tourists' feet, gathering up their crumbs. Usually this mouse is a seedeater of the veld, active mainly by day, and breeding whenever conditions are suitable.

Baby mice are born blind and naked, kept in a nest with their mother, and are wholly dependent on her care in the first few weeks. While the father plays no role in bringing up the baby mice, the mother shows great determination in ensuring that her genes will be represented in the next generation.

MOUSE

The snorts of a tractor's exhaust pipe,
the rip of a plough through maize.
I paused at noon, raised the disc-rack
and sat against a thick-flanged tyre.

The highveld sky, the cloud-rafts,
my bottle of cold sweet tea
hazed out of focus when I saw you
limping around a furrow's clod.

I smelt the reek of black-jack weeds
crushed into hot dry soil
and saw a rounded nursery of grass
upended in a chaos of stalks.

Your infants wriggled in the sun,
pinkish, half blind and bald.
I watched you drag them one by one
into the hospice of the weeds.

The what and how of the universe,
you prompt me now to say,
is glimpsed in Hubble's telescope
and Einstein's scribbled sums.

But the why of life on this aired speck,
the why eludes all science,
and writes its suffering and its hope
in eyes like yours, mother mouse.

Orthosuchus (*Orthosuchus stormbergi*)
Reptilia: Archosauria: Crocodyliformes:
Family Protosuchidae

In body design a forerunner of our modern crocodiles, *Orthosuchus* was a much smaller animal, less than one metre long. Its fossils come from Karoo sediments dating back 200 million years.

Perhaps like present-day juvenile Nile crocodiles, it hunted in the shallows and smaller streams, catching dragonflies, frogs and small fish. Crocodiles have a long fossil history, and like many other groups, giant forms (fifteen metres or more in length) appeared in the past.

Crocodiles lay eggs and show unexpected solicitude for their young, guarding their nests. For some of their dinosaur cousins, there are fossil nest sites with associated skeletons that suggest parental care.

Birds are the other living descendants of this lineage, and thus their nesting behaviour may have a long prehistory. But with only the bones, not even tracks, we cannot reconstruct more than a muscled skeleton for *Orthosuchus*, with the form and the colour of the skin just speculation.

ORTHOSUCHUS

Your bones lie where you fell, a jaw-beam, a curve of spine ridging across a ledge of shale.
You were a late Triassic icon, a reliquary of swamp and fern, an abstract sculpture on a plain.

A chisel lay beside a bone-rise. I could just make out your tail, the croc-outline of your whole.
Did you die snarling in combat or in the silt-tumulus of a flood that hieroglyphs bones like yours?

Squatting beside you in the scrub, I felt the sun burning my neck, the past gaping under my boots
as I traced with my fingertips your spine's weathered-out art. I suddenly knew who you were.

You were an ancestor of Atlas, that massive, unfinished statue, whose straining, muscular torso
is still emerging from the sweat, the growls and chiselled sparks of Michelangelo's studio in Rome.

Cranium, neck locked in marble . . . I saw it then. A few billion years since life first stirred on this rock,
you, that impassioned Atlas and I are still trying to drag our heads out of a lump of primordial stone.

Owl (Wood Owl) (*Strix woodfordii*)
Aves: Strigiformes: Family Strigidae
uil (A) *sephoko* (S) *isikhova* (X) *isikhova* (Z)

The calls echoed in the poem can be attributed to the wood owl, smaller than eagle owls and lacking their ear tufts.

Wood owls nest in tree holes and may roost there by day, or in the branches of trees, close to the trunk. They eat mainly insects and observations of their nest sites suggest that they seldom tackle birds or rodents. Hunting insects at night depends on vision, so their activity is concentrated at dusk and dawn, and on moonlit nights.

Wood owls respond readily to tape recordings of calls of their own species, and individuals can even be identified by their particular call characteristics. This suggests that they have a well-defined territorial system, where the callers may recognise their neighbours.

Our species is not at ease in the dark and the hooting of owls has often led to legends where owls are regarded as birds of ill omen; many peoples believe that owls calling, or landing on a roof, foretell death. The real significance of their calls is more mundane, but still intriguing – do we hear the sound as other owls hear it? How do they interpret the message?

OWL

Tell me, night-hawk,
who-whooing
from that black untidy splotch of a pine,

do you also shiver
with the beautiful
and dangerous love of the stars?

Imagine the infernos,
the heart-throttling cold,
the bone-bursting vacuum above our heads.

Imagine the whirl-holes,
the gusts of fire-dust,
the light-years of loneliness in space.

Who-who are we,
I call back to you,
that we can breathe in such a wilderness

and sing?

Peregrine Falcon (*Falco peregrinus*)
Aves: Ciconiiformes: Family Falconidae
swerfvalk (A) *phaloe* (S) *ukhetshe* (X) *ukhozi* (Z)

Falcons are long-winged aerial hunters and the peregrine falcon is traditionally one of the species most sought after by falconers for its speed and power. Peregrines are specialist bird-hunters that kill in a dramatic high-speed stoop from above, striking birds as large as a big pigeon hard enough to decapitate them. The prey is then carried off to a feeding site, where it is plucked and dissected, the feet and intestines typically laid aside.

In Africa there are breeding birds, always nesting on high cliffs, and also migrant visitors from northern Europe and Asia. At the nest site, the falcons may be aggressive towards climbers, calling agitatedly and swooping at intruders.

In North America and Europe the decline of the peregrine, marked by reduced breeding success, was a vivid warning of the dangers of pesticides accumulating in the environment. The breakdown products of DDT affect the calcium metabolism of birds and comparisons of museum egg collections from the previous century with those collected today show a dramatic thinning in eggshells of these top predators.

Better control of poisons in the environment and a captive breeding programme have re-established peregrines through much of their former range in the northern hemisphere. This has been a great success for conservationists, though not necessarily an appropriate model for restoring other wildlife populations in decline.

PEREGRINE FALCON

Climbing a crag, I heard a *kwaak-kwaak*,
and looked down and saw you scudding
across a river's crinkle on a bushveld plain.

You looked as small and remote as I felt.
You were a dark speeding speck of a bird,
a faint fury hollering, *Get out of my niche!*

Pulling slowly, up and over warm basalt,
I saw a carcase on a balcony in the sky.
I read you then, raptor. Your meat-hunger,

bunching its wings, had hurtled down, down
from out the glaring white zenith of the sun
at the grey fleck of a rock-pigeon far below.

Thump! A blue-black explosion of wings,
a scrunch of talons. A flapping, a jerking
lugged heavily to this abattoir of a ledge.

I stared and stared, at the parable of a kill,
at the stark, almost cryptic life-in-death art
of a headless squab on the table of a feast.

A spillage of granules, loosed from its crop
was already drying its seeds for a new terrain.
A dust-coloured foraging ant, a mite's red dot

enacting some earthed, intrinsic narrative
hurried to the manna of a glisten of blood
as a maggot-fly entered the crib of the wound.

I turned and gazed, out over miles of bush,
awed that the plants, the hunger of animals
made such a simmering green Canaan of death.

I began to love you then. You sky-wrote to me
what you signal my species, when you migrate
and float round the earth: *Leave me to my life.*

Porcupine (*Hystrix africaeaustralis*)
Mammalia: Rodentia: Family Hystricidae
ystervark (A) *noko* (S) *incanda* (X) *ingungumbane* (Z)

Porcupines have always been mammals of the night, like many other rodents. Burrows provide a refuge by day, either those they dig themselves, or old aardvark excavations.

Porcupines accumulate bones to gnaw on in the burrows, leaving small caches for future archaeologists, who must learn to distinguish bones gnawed by porcupines from those chewed by predators, and from those cracked or cut by our ancestors.

Porcupines are widespread in Africa as their fallen quills reveal and yet they are seldom seen. The quills are not shot from the body, but work loose and are shed periodically like old hairs, so at times they can be dislodged by a vigorous shake.

The quills provide little protection from people, who regard porcupines as good eating meat, as well as a nuisance in the vegetable patch.

So they have good reason to fear people. Inexperienced attackers such as dogs, and even young lions, can be badly injured by the quills, which lodge in their mouths and faces, but skilled predators will go for the unprotected belly.

PORCUPINE

I track your existence only by your residues:
a quill by an ant-heap, claw-scrapes in reeds,
a row of cabbage-heads chewed in a field.

Am I more of a shade, more palpable to you?
That baked soil shudder as the plough rips in,
that whiff of my sweat churning your bowels?

Hearing the farm-dogs barking in the thicket
that thorns your lair I think of your lifeline
laying down spoor for millions of years

until its end in this age. How I rue the refugee
we've turned you into, the indigenous clansman
despoiled of his land, the stowaway on an ark

that travels deep space, sniffing the hen-coops,
gnawing at grain-sacks, terrified of Noah.

Rhinoceros (White Rhino) (*Ceratotherium simum*)
(Black Rhino) (*Diceros bicornis*)
Mammalia: Perissodactyla: Family Rhinocerotidae
renoster (A) *nare* (S) *umkhombe* (X) *ubhejane* (Z)

White rhinos, square-jawed grazers, are herd animals and more placid than the solitary black rhinos. However, both species have bad eyesight and may react to disturbance with a thunderous, unpredictable charge.

Rhinos are icons of the conservation movement in Africa and the two species survive only in a handful of well-protected reserves, notably in South Africa. Close encounters, whether on foot or in a vehicle, are a highlight for any visitor, with the added spice of danger from the animals' uncertain temperament.

The golden rhino from the iron-age site at Mapungubwe dates back about 750 years, and is adjudged to be a white rhino. So is the animal photographed in the poem, although the description of feeding recalls the browsing of a black rhino.

Historically the white rhino was restricted to the northern and eastern savannas of South Africa, whereas the black rhino extended south as far as the slopes of Table Mountain. Early travellers described five different 'species' of rhino, based on horn shapes rather than mouth structure. Johann Wahlberg, a Swedish collector, shot more than 70 rhinos on his travels, trying to resolve this puzzle.

RHINOCEROS

A gully of thorn-bush, smitten by the heat.
Ant-heap pinnacles, like Gaudi's cathedral.
And sightings, in cycads, of pale grey hide.
Ear-scallops. The dusty boulder of a rump.

You were a saga upwind of me. Had been,
for millions of years. A Pliocene mammal
getting on with it. That maw of a mouth
lipping, ripping, grinding scrub to a mash.

I sat in a jeep, my camera aimed like a rifle,
and zoomed in. On a snuffling, slobbering,
pig-eyed cranium. A calloused flange of lip.
Click. I bagged in pixels a kill of your being.

What art, I thought, could begin to semaphore
the instincts delicately latticed in your genes,
the shoals of blood-sacs bred in your marrow
and your whole horned hunger to live, live, live?

A month or so later, back home at my desk,
tracking your spoor through the internet bush,
I marvelled at what an artist had made of you
years ago in Mapungubwe's hill-top smithy.

You were a small, austere replica of your self,
a talisman crafted by the sculptor in a village,
a totem whittled from wood and skinned in gold
to strengthen and beautify the life of the clan.

I gazed and gazed, at the stump-strong legs,
the hippo-squat bulk, a head dropped to charge,
loving your lustre, your bony snort of a tail.
And then you charged, right out of the screen

into the word-carved talisman of a poem.

Salmon (*Salmo* spp.)
Osteichthyes: Salmoniformes: Family Salmonidae

Although the name 'salmon' is applied to some South African fish, true salmon occur only in the northern hemisphere. This is one of the fish species that breeds in fresh water and then spends its adult life at sea.

Salmon are imprinted at birth with the chemical characteristics of their natal streams and thus 'smell' their way back. They forge upriver, challenging every rapid on the way, and running the gauntlet of anglers and other fishers, such as bears.

Breeding for some creatures, including salmon, is both culmination and termination. Salmon finally spawn in the calmer headwaters and die, with their spent carcasses putting nutrients back into the river. The young fish in turn swim downstream to the sea, until their voyage home is scheduled.

Fish ladders on some rivers enable the salmon to bypass dams and to preserve their traditional routes. However, pollution has eliminated salmon from many rivers and it is hard to imagine that a few generations ago, peasants in Brittany complained of an unvaried diet of salmon during the spawning season on the Atlantic coast of France.

SALMON

My imagination stalks you.
An angler, cautious, canny,
working a stream in a wood.
Granule by granule, the moss,
the soil-mulch tilths my mind.

Then – mist-wraiths on a lake.
Pine-gloom. Crows up high.
A clouded peak in Canada.
A river like a strand of light,
a cold clarity of salmon time.

I peer inside the water's moil,
awed by your navigation,
your leaps of will up the rapids
and the gift of self you make
that the lifeline might survive.

I grunt as I picture you floating
belly-up, your sleek fuselage
a flesh-wreck after you spawn.
What muscles you over the weirs
then snuffs you, Sisyphus?

At last, under a log's black rot,
I glimpse you. A gleam of silver
that has swum a thousand miles.
A longing to go home, sniffing
the gravel where you were born.

Shoef! You miracle my words.
Shoef! Misting through water
gust after gust of sperm,
each cloud more numerous
than all the people in the world.

Seahorse (*Hippocampus* spp.)
Osteichthyes: Actinopterygii:
Family Syngnathidae
seeperdjie (A)

In design, seahorses are quite unlike conventional fish, with their upright posture, prehensile tails, armoured bodies and horse-like heads. Whereas most fish swim by using their tail fins, seahorses use the single dorsal fin protruding halfway along the body, more like a stubby wing. Seahorses are most closely related to the pipe fish, slender fish that mimic the vertical strands of seaweed among which they hide.

After the ritual courtship dance, the male takes the eggs into a pouch where they are fertilised and then brooded until they hatch. After that the young are on their own.

Male parental care is often found in fish and amphibians; in theory, a male can only be certain of his paternity when the eggs have been fertilised outside the body of the female. Seahorses have taken this a step further by their unique male pregnancy.

Often we attribute human virtues to animals, even though we know little of their lives as individuals. Most of our knowledge of seahorses depends on observations in aquaria and we do not know how long a partnership endures in the wild weeds.

SEAHORSE

I saw you first behind thick glass.
A horse-head in a sea-grass forest,
a spiral of tail curled round a stem.

The short stubby fin on your back
began to undulate its fan-thin ribs.
You flew slowly through your air.

You reminded me then of Pegasus.
Of catfish and whiskered molluscs
in the salt marshes of your lagoon.

Of Ovid's mind, where vegetation,
people, animals and deities merge
in the estuarine tides of mythic time.

I pressed my forehead to the glass.
Your green had an octopus mottle.
Your eye-glance was all chameleon.

Nearby, a sprinkle of infants hung,
as spindly as plankton mosquitoes.
You'd reared their eggs in a pouch,

a kangaroo womb until their birth.
Were you creation's perfect male?
A sea-mare floated from a reed,

your partner, your spouse for life.
I wondered if she knew emotion
and felt what we suppose is love.

The bone-hoops beneath her skin
gave her a crinoline, a bridal look.
Your daily wedding dance began.

She glided down an aisle of pillars,
entwined her curl of a tail in yours
and rose slowly, twirling with you

within a watery tabernacle of life.

Sheep (*Ovis aries*)
Mammalia: Artiodactyla: Family Bovidae: Sub-family Caprinae
skaap (A) *nku* (S) *igusha* (X) *imvu* (Z)

Wild sheep survive today in mountainous areas in Europe, with other species in Asia and North America. It seems that sheep were first domesticated in western Asia about 8 000 years ago. They came to Africa with returning migrant humans, long after the first great exodus from Africa had peopled the world.

Sheep are herd animals, following a leader to new grazing areas and not site-bound in a defended territory. The aggression of the rams must be tempered with submission to a new leader, which may explain how they come to accept a human master.

Long before Mendel demonstrated the rules by which physical characteristics are inherited, sheep breeders were selecting for desirable characteristics such as better wool, more meat, and responsiveness to shepherds and dogs.

Today with the return of wolves and other predators to sheep-country, farmers are turning to formidable guard-dogs, which had become unfashionable. Socialised with sheep as puppies, the dogs live with the flock and protect their adopted family. The use of dogs means no traps or poisons, which would disturb the traditional balance of nature.

SHEEP

Remember me, meek mother of lambs?
I'm the hunter-man, the roamer of plains
with a poisoned arrow and a digging stick.

I owe you, ma'am. For roasts and broths
and winter woollies. For thousands of years
of offerings to my blood-line in the wild.

We've grown a bit now, and multiplied.
Our kids wear shoes, and go to school.
No more huddling with you in a cave.

I owe you and the poultry and the pigs,
the milk-cows, plough-oxen and goats.
Do you read me? I want to say, *Thanks*.

Silence. Thousands of years of silence
pouring into the place-time I stand in,
a grazing-camp on a plateau of Africa.

Silence, and then the click of hooves
crossing bedrock, the *baa* of an ewe
being trailed by a lamb inside a fence.

Silverfish (Fishmoth) (*Ctenolepisma longicaudata*)
Insecta: Thysanura: Family Lepismatidae
silwervis (A) *inundu* (X)

'Primitive' is a loaded, emotive word, but silverfish are indeed among the most ancient insect types. They are wingless and therefore without the apparent advantages of 'more advanced' flying insects.

Direct sperm delivery to an appropriate partner seems the most efficient system, utilised by almost all terrestrial animals today.

Fishmoths retain a more haphazard system, whereby males leave drops of sperm on stalks, and passing females collect them without ever meeting their mate. Eggs are abandoned without any parental care.

Success and survival are the final measures in the evolutionary contest. Here silverfish rank high; one cannot disregard 390 million years of history, and the ability to live in apparent deserts of paper, drawing all the necessities of life from such limited material, while continuing to evade the countermeasures of librarians and bibliophiles.

SILVERFISH

Get out of here, moth-head! Stop eating my *Mariner of the Nebulae*!
Have you no respect for Hubble? For Science? It's no use pretending.
Your grandma might have outsmarted *Tyrannosaurus* in the swamps

but I ain't going to let you foodweb my shelf. So beat it, bookworm.
And now, why the scowl? Tell me, squiggler, where's that dew-drop,
the sperm-speck I saw glistening in the gossamer lover-boy spun?

I reckon, madam, it's in your tubes and all the energy of the cosmos
is still aching, aching to conceive. No wonder you look sort of dazed.
I'd say, Madonna of the insects, two tiny universes of chromosomes

are dancing their quarks together inside the sanctum of your womb
and singing singing, *mm, mm, mm.* Ag no, my pearly paper-pilferer,
your conception's way beyond me. You've got me, right on the raw.

That soft-bodied land-fish of yours is trim and silvery and beautiful
as the rim of the newest new moon and I can't, I just can't bear to squish
the millions of years of your Magnificat beneath the club of my thumb.

Spider (Rain spider) (*Palystes* spp.)
Arachnida: Araneae: Family Heteropodidae
spinnekop (A) *sekgo* (S) *isigcawu* (X) *isicabu* (Z)

Snakes or spiders – which animals evoke the most widespread rejection? There are zoologists who handle reptiles without a qualm, yet flinch from a moderate-sized household spider.

Rain spiders are rather more impressive; they are hairy, long-legged hunters that don't live in webs. They have a striking threat display, with raised legs and spread chelicerae (the biting mouth-parts), but seldom bite when handled gently. Apart from a variety of insect prey, they will capture other small animals such as geckoes. The larger females leave silky packages, suspended by many bracing threads, in shrubs and hedges. Dozens of tiny spiders will duly emerge, long after their mother has died.

Almost all spiders have poison fangs, though few are dangerous to animals as large as human beings. The largest and most horrifying to arachnophobes are the bird-eating spiders of South America.

One starred briefly in the James Bond film *Dr No*. This particular female lived for more than twenty years in the London Zoo, appeared in several films and never bit anyone. She even merited a short obituary in the newspapers. We should think of spiders as allies in a world that might otherwise be overrun by insects, many of which are damaging rather than beneficial to our planetary ambitions.

SPIDER

Hot and stifling the night.
The stoep-door like a portal
to Rousseau's green fronds.
To goat-stink. Feral stings.

With wife, two kids on a rug
I smelt subtropical perfumes
and heard the clicking of bats
devouring moths like plums.

Watch out! a voice screamed.
I saw a murk, a haired phobia
spidering in over the threshold,
the knees of its baboon legs

pistoning fast over the tiles.
Suddenly I was all reptile.
I grabbed a book and beat it,
beat it to a squirm, a smear.

Don't laugh. Your turn soon
to face a predator, its eyes
intent on you and glittering,
attacking you out of the dark.

Tortoise (*Padloper*) (*Homopus areolatus*)
Reptilia: Anapsida: Family Testudinidae
skilpad (A) *kgudu* (S) *ufudo* (X) *ufudu* (Z)

Tortoises are an archaic group that fit awkwardly into the category of modern reptiles. Their ancestors predated the mammal-like synapsids, dinosaurs and birds.

Living enclosed in a shell, with ribs and backbone fused to the carapace, is clearly a successful design. However, withdrawing into the shell when disturbed is not an appropriate response in some situations, such as when crossing a road or touching an electric fence.

South Africa has several endemic tortoise species and the *padlopers* are among the smallest of them.

All tortoises lay eggs, left buried in the soil. Thus there is no contact between parents and young, no exchange of wisdom from old veterans to their successors.

The rings of scales on tortoises' shells reflect a minimum age, though in old animals, the outer layers will have worn off. It is suspected that some individuals may survive for a century.

Drivers seldom try to avoid wildlife unless the animals are large enough to damage a vehicle severely, and road kills are as common a cause of mortality for tortoises as for other animal groups.

TORTOISE

Driving to the sea, through rock-shrub,
shimmers of heat, spring-storms of bees,
I braked hard, seeing your beige knoll,
your helmet-dome on the road ahead.

Ag no, I groaned, *not another corpse.*
The road was a corridor of carnage.
Snake, skunk, a hawk, a feather up
lay splattered flat, grilling on the tar.

But no, you clawed slowly forward.
I veered off the road and jumped out,
wanting to shove under the fence-line
your fortress, your tabernacle of horn.

You saw me, looming on the verge,
and paused, lifting your reptile snout.
Your kin had plodded the same shale,
had chewed the same scrub when mine

were tiny-handed, scuttling shrews.
I sensed millions of years of tortoise
assessing my silhouette in the sky.
Your ganglions flickered. Your head

and claws fled back into your shell.
You hunkered down on the road.
Whaaaaar! A truck clobbered past,
its driver hooting and flashing lights.

I staggered in the backwash of dust,
then hurried across to pick you up.
The nave of your shell was shattered.
Your blood trickled over my hands.

Warthog (*Phacochoerus africanus*)
Mammalia: Artiodactyla: Family Suidae
vlakvark (A) *kolobe-moru* (S) *inxagu* (X) *indlovudawana* (Z)

Their ugliness is almost endearing and when warthogs trot away, tails erect, most people watch them with amused affection. Getting down on their knees to graze, warthogs can keep grass well trimmed. Their tusks are impressive weapons; nevertheless they do not rank as dangerous like bushpigs or even feral domestic pigs. However, a determined female defending her piglet has proved a match for a pack of wild dogs, a cheetah, and even a passing leopard.

Warthogs are frequent prey of lions and other large predators, so at night they retreat to the safety of a burrow. These are often old aardvark excavations, which the warthog enters backwards, ready to make an explosive exit in an emergency.

Warthogs also dig their own burrows and make temporary foraging excavations. In farming areas, they exasperate farmers by digging under fences, so that the enclosures are no longer secure from small predators, nor effective in keeping livestock from wandering.

It appears that warthogs were mistakenly introduced to the Eastern Cape on the assumption that they had occurred here in the past. This is debatable, but they are flourishing and expanding their range throughout the region today.

WARTHOG

Sunset. A wilderness of aloes,
biblical in its rocks and thorns.
The portal to an aardvark's den,
grassed-in and shaggy with webs.

The aloes burned red in the gloom.
Stick in hand, I crouched closer,
wondering how aeons of termites
could sculpture a lifeline of genes

into a lonely sniffer of the night
tongued like a giant chameleon.
My son, just back from a reserve,
tugged at my naturalist's wand.

What pressures sculptured us both?
I'd trudged a sun-scoured plateau
of fossils all day, was lost to him
as I drifted into a Permian reverie.

I could see the ghosts of reptiles
shuffling across the mud-flats
of a marshy Gondwanaland basin
beneath such a cavernous dark,

such a huge mausoleum of stars
I wanted like a nomad Abraham
to get down on my knees and bless,
bless the miracle of being alive.

'Dad, don't warthogs sleep in . . .'
A squeal, a shriek from the hole.
A thunderbolt of tusked muscle
blasted between us into the bush.

My son stared at me wide-eyed,
an Isaac to a ram in the thorns.
No longer was father omniscient.
Nature was greater than Man.

Worm (a body form, rather than a specific animal)
wurm (A) *manyoa* (S) *umsundulu* (X) *umsundu/inkamba* (Z)

All life was aquatic at first and only later did land animals and plants appear. Before internal bones or rigid external skeletons, animals had hydraulic skeletons filled with fluid. Even today, a body cavity containing liquid and surrounded by muscles serves well for large sessile sea-squirts such as redbait, and on land for mobile leeches or slugs.

The design exemplified by the earthworm is clearly appropriate for a burrowing animal, and there are limbless amphibians (caecilians) and reptiles (amphisbaenids) that show a striking resemblance to earthworms in external appearance.

Soft-bodied creatures were seldom fossilised, so tracing the details of the past is speculative in the early days of life on earth. We can deduce that worm-shaped creatures were our pre-vertebrate forbearers, with sense organs and nerves concentrated at the head end near the mouth.

Fossils, logic, and the links implied by the genetic material in animal cells, guide the search for the story of our distant past, a history that we, the self-anointed victors, are constantly rewriting.

WORM

Fairest of forebears, denizen of a puddle
of blood-warm brine, how goes the grub?

A snout lifts, bulges the pool's meniscus
and then sinks back. Billennia slide by.

Is this life's nursery, the biological Eden?
No love affairs yet. No pyramids, or Bach.

You all look so skinny, so cramped and bored,
like fingerlings of cells languorous in a font.

If you can't imagine the spines and hands,
the farms and cities curled in your genes,

what metamorphoses of eye and intellect,
of spaceship and temple are still enfolded in me?

Time aeons onwards. A cell-thread, mutated,
snuffles at the ceiling then thrusts its snout,

eyeless, inquisitive, dripping with water,
up into *terra incognita*, the sunlit atmosphere.

Zebra (Burchell's zebra) (*Equus burchellii*)
Mammalia: Perissodactyla: Family Equidae
sebra (A) *qwaha* (S) *iqwarha* (X) *idube* (Z)

Fat and sleek, grazing zebras are one of the standard images of the African plains. The contented herds conceal sub-groupings of single males who dominate small harems of females and they will fight vigorously for this privileged position.

Each zebra has a stripe pattern as unique as a fingerprint, recognisable to human observers with practice, and so probably also to other zebras. Horse-like in behaviour, zebra have been trained to draw carts, though not to tolerate a rider on their backs.

Zebras are the prey of lions, hyenas and wild dogs, so some of the group are always alert. Yet after a kill they seem to recognise that the predators are no longer in hunting mode and show only mild curiosity at the fate of one of their fellows.

Zoologists also look beneath the skin, where other life is concealed. The well-rounded body of the average zebra hides a host of worms, up to six million internal parasites for each animal, according to one parasitologist. So even while alive, zebras provide food for a multitude of other animals.

ZEBRA

I drew off the road and through my binoculars
glimpsed the mounded lineaments of your body
brindled with blood near a clump of green reeds.

The black and white stripes around your neck
were smeared with mud where you'd writhed.
The pouch of your belly had already been ripped.

I could still make out, beyond the thorn-trees,
your dapper kin, slowing to a walk, dropping
their heads and nibbling the sweet spring grass.

You slumped there, in death still magnificent.
I felt appalled, and then dispassionate, in turns.
This was the Africa, the Eden of the brainstem,

the inescapable waterhole, as primal and frank
as a mottled hyena sidling through the bush,
the reddened muzzle, the snarl of a lion.

What makes us live – carbon cooked in the stars,
the demiurge of the genes, the God who sustains
the whole explosive energy of the cosmic design?

Lying wide-eyed in the reeds, you tutored more.
Into the vlei-side rite I focused on from the car
a sprawl of cubs came tumbling, tawny, playful,

as innocent of malice as the tortoise in the scrub,
the warthog wallowing in a mud-hole by the road.
With flattened ears, they ate into your sacrifice.

Scented-pod Acacia (*Acacia nilotica*)
Plantae: Family Fabaceae
doringbos (A) *hanyane* (S) *umnga* (X) *umunga* (Z)

The scented-pod acacia is the common thorn tree in the KwaZulu-Natal midlands. Other thorny acacias are found throughout Africa and in the Mediterranean region, including Israel. Like all trees, acacias process humans' exhaled carbon dioxide, utilising this gas in the course of photosynthesis, and in turn releasing oxygen, on which all breathing animals depend.

The seed pods house many insects, and attract many birds that feed on them. The tough black bark conceals other arthropods in its ridges, including tiny pseudoscorpions (they lack tails), with eight legs and pincers, which spin silken retreats in the trees' crevices.

Both the foliage and the pods are palatable to domestic stock and wild game, so that the trees often show a clear browse line.

Thorns alone are often not enough to deter herbivores, and many acacias also house colonies of aggressive biting or stinging ants. Greatly swollen thorns provide secure homes for these boarders, which swarm out to attack anything that disturbs their branch. The flowers of the scented-pod acacia are small yellow pompoms, which appear in late summer, and are visited by a different group of insects.

EPILOGUE: THORNBUSH

Howzit, Light-catcher!
Hell, you're a survivor,
so goat-bitten yet *green!*

Listen, listen to my heart.
Sssssssh – can you hear it?
Lub-dup, it sings, *lub-dup,*

flushing my blood-thirst
through the soft red sponges
that crave your exhalation.

How many billion photons
and bushes and heart-beats
do we go back, Leaf-lung?

Me and mine spewing out
that sweet-poison nimbus
you chow like airy waste.

You and yours leaching
the pre-Cambrian fug-up
asphyxiating the planet,

fattening hulked vegans
on foliage and air-flesh,
schlepping my forebears

to crawl up on a beach
and wave a chewed fin
and gasp, gasp those gills.

Now breathe, Fish-face,
you fumed at my lifeline,
breathe us – or drop!

Jeez, Thorn-head,
how you still oxygen
each panting cell,

each word of me.

ACKNOWLEDGEMENTS

Versions of some of these poems appeared in the following publications to whose editors our thanks are due: *Carapace, English Academy Review, Labyrinth, New Coin, New Contrast, Scrutiny2* and *Rhodos.*

The authors and artist have benefited enormously from the support and creative comments of a wide range of people, too numerous to mention individually here. To them we would like to express our gratitude. Specific assistance of a technical nature relating to the text and artwork was received from the following to whom we would also like to express our thanks: Susan Abraham; Albany Museum, Grahamstown; Molly Brown; Jim Cambray; Cheryl Craig; Billy de Klerk; Ezulwini Game Lodge for images of blesbuck; Colin Gardner; Michael Ginn; Priscilla Hall; Randall Hepburn; Sally Hines; Tim Huisamen; Russell Kaschula; Alison Lockhart; Jackie Lockyear; Amy Mann; Luke Mann; Mapungubwe Museum, University of Pretoria, for image of golden rhino; Mandla Matyumza; Peter Mtuze; Vincent Motebang Nakin; Lynette Paterson; Cossie Rasana; Jackie Shipster; John Skinner; South African Museum for image of orthosuchus; Andrew Taylor; Malvern van Wyk Smith; Irene Walker; John Walters; Laurence Wright; www.fishing-scotland.co.uk for image of Atlantic salmon.

SELECT BIBLIOGRAPHY

Achenbach, J. 2003. 'Dinosaurs Come Alive'. *National Geographic* 203 (3): 2–31.
Alcock, J. 2001. *Animal Behaviour: An Evolutionary Approach.* Sunderland: Sinauer Associates.
Attridge, D. 1982. *The Rhythms of English Poetry.* London: Longmans.
Bannister, A. 1985. *South African Animals in the Wild.* Cape Town: CNA/Struik.
Barrow, J.D. 1986. *The Anthropic Cosmological Principle.* Oxford: Oxford University Press.
———. 1998. *Impossibility: The Limits of Science and the Science of Limits.* Oxford: Oxford University Press.
Bell, E.M. et al. 2003. 'First Field Studies of an Endangered South African seahorse, *Hippocampus capensis*'. *Environmental Biology of Fishes* 67: 35–46.
Boycott, R. and Bourquin, O. 1988. *The South African Tortoise Book.* Cape Town: Southern Book Publishers.
Branch, G.M. et al. 1994. *Two Oceans: A Guide to the Marine Life of Southern Africa.* Cape Town: David Philip.
Burnett, W.R. et al. 1958. *Zoology: An Introduction to the Animal Kingdom.* London: Paul Hamlyn.
Cambray, J.A. 1996. 'Threatened Fishes of the World: Sandelia bainsii Castelnau, 1861 (Anabantidae)'. *Environmental Biology of Fishes* 45: 150.
Cameron, A. 1979. *Birds: Their Life Their World.* New York: Readers Digest Assoc. Inc.
Christianson, G.E. 1995. *Edwin Hubble: Mariner of the Nebulae.* Chicago: University of Chicago Press.
Cluver, M.A. 1978. *Fossil Reptiles of the South African Karoo.* Cape Town: South African Museum.
Cope, T. 1968. *Izibongo: Zulu Praise Poems.* Oxford: Oxford University Press.
Coughlan, R. 1966. *The World of Michelangelo.* Time-Life International (Nederland).
Darwin, C. 1883. *The Descent of Man.* London: John Murray.
Davies, P. 1983. *God and the New Physics.* Harmondsworth: Penguin.
Dawkins, R. 1976. *The Selfish Gene.* Oxford: Oxford University Press.
De Klerk, W. 2002. 'A Dicynodont Trackway from the Cistecephalus Assemblage Zone in the Karoo, East of Graaff Reinet, South Africa'. *Palaeontologia Africana* 38: 73–91.
Diamond, J. 1997. *Guns, Germs and Steel.* London: Chatto & Windus.
Drees, W. 1990. *Beyond the Big Bang: Quantum Cosmology and God.* La Salle: Open Court.
———. 1996. *Religion, Science and Naturalism.* Cambridge: Cambridge University Press.
Edey, M.A. 1973. *The Missing Link.* Time-Life International (Nederland).
Ellis, M. 1971. *The World of Birds.* London: Hamlyn.
Exploring Space: The Universe in Pictures. 2004. National Geographic Collector's Edition Vol. 7. Washington: National Geographic Society.
Filmer, R. 1991. *Southern African Spiders: An Identification Guide.* Cape Town: Struik.
FitzSimons, V.F.M. 1970. *A Field Guide to the Snakes of Southern Africa.* London: Collins.
Fortey, R. 1982. *Fossils: The Key to the Past.* London: Heinemann.
Gallant, R.A. 1980. *National Geographic Picture Atlas of Our Universe.* Washington: National Geographic Society.
Gould, S.J. 1989. *Wonderful Life.* Harmondsworth: Penguin.
———. (ed.). 1993. *The Book of Life.* London: Random House.

Halle, M. et al . 1971. *English Stress: Its Form, its Growth, its Role in Verse.* New York: Harper & Row.

Hamer, D. 2005. *The God Gene.* New York: Doubleday.

Hare, T. et al. 1986. *Rats and Mice: Animal World.* London: Cavendish.

Hosking, E. 1982. *Owls.* London: Pelham Books.

Hull, D.L. 1998. *The Philosophy of Biology.* Oxford: Oxford University Press.

Kaku, M. 1998. *Visions: How Science will Revolutionize the 21st Century and Beyond.* Oxford: Oxford University Press.

Koestler, A. 1964. *The Sleepwalkers: A History of Man's Changing Vision of the Universe.* Harmondsworth: Penguin.

Life before Man. 1973. Time-Life International (Nederland).

Little, C. 1983. *The Colonisation of Land.* Cambridge: Cambridge University Press.

Lockyear, J. n.d. *The Knysna Seahorse.* Grahamstown: Seahorse Research Group, Rhodes University.

Londt, G.H. 1994. *A Guide to Insects of Southern Africa.* Pinetown: The Wildlife Society of Southern Africa.

Mayes, S., Hargreaves, A., et al. 1991. *How Do Animals Talk.* London: Usborne Publishing.

Migdoll, I. 1997. *Butterflies of Southern Africa.* Cape Town: Struik.

Miller, K. 2000. *Finding Darwin's God: A Scientist's Search for Common Ground.* New York: Cliff Street Books.

Moore, P. 1988. *Space Travel.* London: George Philip.

Myers, J.G. 1929. *Insect Singers: A Natural History of the Cicadas.* London: Routledge.

Opland, J. 1998. *Xhosa Poets and Poetry.* Cape Town: David Philip.

Penrose, R. 1999. *The Emperor's New Mind: Computers, Minds and the Laws of Physics.* Oxford: Oxford University Press.

Pimm, S.L. 1982. *Food Webs.* London: Chapman and Hall.

Pinna, G. 1985. *The Illustrated Encyclopedia of Fossils.* New York: Facts on File.

Polkinghorne, J. 1987. *One World: The Interaction of Science and Theology.* London: SPCK.

———. 1998. *Belief in God in an Age of Science.* New Haven: Yale University Press.

Rhodes, F.H.T. et al. 1965. *Fossils: A Guide to Prehistoric Life.* London: Paul Hamlyn.

Roberts, A. 1949. *The Birds of South Africa.* London: H.F. & G. Witherby Ltd. for The Trustees of the South African Bird Book Fund.

Rose, W. 1950. *Reptiles and Amphibians of Southern Africa.* Cape Town: Maskew Miller.

Sagan, C. 1999. *Cosmos.* London: Abacus.

Sarles, H. 1977. *After Metaphysics: Towards a Grammar of Interaction and Discourse.* Lisse: The Peter De Ridder Press.

Seymour, P. and Cassels Helmer, J. 1984. *Insects: A Close-up Look.* Los Angeles: Child's Play International.

Silby, J. 2001. *Dragonflies of the World.* Collingwood: CSIRO Publishing.

Skaife, S.H. 1953. *African Insect Life.* Cape Town: Longmans.

Soskice, M.J. 1985. *Metaphorical and Religious Language.* Oxford: Clarendon Press.

Tarpy, C. 2005. 'China's Fossil Marvels'. *National Geographic* 208 (2): 86–97.

Terblanche, E. 1979. *Ken ons Kleinvee-rasse.* Cape Town: Human and Rousseau.

Thompson, D. 1977. *Nature's Way: House Mouse.* London: Andre Deutsch.

Van der Elst, R. and Thorpe, D. 1995. *Common Sea Fishes of Southern Africa.* Cape Town: Struik.

Van Zyl, A. 1994. 'Aspects of the ecophysiology of three ant lion species in the Kalahari'. PhD thesis, University of the Free State, Bloemfontein.

Vaughan, R. and Murphy, I. 1994. *Zimbabwe: Africa's Paradise.* London: CBC Publishing.

Walker, E. 1975. *Mammals of the World.* Baltimore: Johns Hopkins University Press.

Ward, K. 1996. *God, Chance and Necessity.* Oxford: One World.

Weaver, K.F. and Brill, D.L. 1985. 'The Search for our Ancestors'. *National Geographic* 168 (5): 561–623.

Weaving, A. 2000. *Southern African Insects.* Cape Town: Struik.

Wheeler, W.M. n.d. *Demons of the Dust.* London: Kegan Paul Trench.

Wood, P. et al. 1972. *Life before Man.* New York: Time Life International.